LEITH
HISTORY TOUR

First published 2018

Amberley Publishing
The Hill, Stroud,
Gloucestershire, GL5 4EP
www.amberley-books.com

Copyright © Jack Gillon &
Fraser Parkinson, 2018
Map contains Ordnance Survey data
© Crown copyright and database right
[2018]

ISBN 978 1 4456 7807 8 (print)
ISBN 978 1 4456 7808 5 (ebook)

British Library Cataloguing in
Publication Data.
A catalogue record for this book is
available from the British Library.

Origination by Amberley Publishing.
Printed in Great Britain.

INTRODUCTION

Leith was first established on the banks of the Water of Leith, at the point where the river entered the Firth of Forth. The first historical reference to the town dates from 1140, when the harbour and fishing rights were granted to Holyrood Abbey by David I. The early settlement was centred on the area bounded by the Shore, Water Street, Tolbooth Wynd and Broad Wynd.

Leith became Edinburgh's port in 1329 when Robert I granted control of the town to the burgh of Edinburgh. Further royal charters during the fifteenth century gave Edinburgh the rights to land adjoining the river and prohibited all trade and commercial activity by Leithers on the ground owned by Edinburgh.

Leith constantly features in the power struggles that took place in Scotland and the battles, landings and sieges of Leith have had an influence on its development. It was attacked by the Earl of Hertford in 1544 during the Rough Wooing; his mission was to arrange a marriage between the young Mary, Queen of Scots and her English cousin, later Edward VI. Three years later, Leith was pillaged after the defeat of the Scottish Army at the Battle of Pinkie. Immediately following this, Mary of Guise, the Roman Catholic Regent of Scotland, moved the seat of government to Leith and the town was fortified.

In the second half of the eighteenth century regular streets, including Bernard Street and Constitution Street, were built on the edges of the town and Queen Charlotte Street was cut through the

medieval layout. Leith became a fashionable seaside resort that, as early as 1767, included a golf clubhouse, built by the Honourable Company of Edinburgh Golfers, at the west end of the Links.

Leith expanded significantly during the nineteenth century, with railway building and the growth of the docks. Port-related industries and warehousing also grew rapidly during this period. This contemporary description paints a vivid portrait of the port at the time:

> Leith possesses many productive establishments, such as ship-building and sail-cloth manufactories ... manufactories of glass ... a corn-mill ... many warehouses for wines and spirits ... and there are also other manufacturing establishments besides those for the making of cordage for brewing, distilling, and rectifying spirits, refining sugar, preserving tinned meats, soap and candle manufactories, with several extensive cooperages, iron-foundries, flourmills, tanneries and saw-mills.

In 1833, Leith was established as an independent municipal and parliamentary burgh with full powers of local government. The town expanded as massive warehouses and additional docks were built: the Victoria Dock in 1851, the Albert Dock in 1881 and the Imperial Dock in 1903.

After the passing of the Leith Improvement Act in 1880, many of the slums and most of the sixteenth- and seventeenth-century buildings were cleared away. This coincided with programmes of major tenement development, in particular the building of dense tenement blocks over the fields between Leith Walk and Easter Road.

In 1920, the town was amalgamated with Edinburgh. By the time of the amalgamation, Leith contained its successful port, significant

industrial enterprises, shipbuilding yards, warehouses, bonds and a population densely packed into ageing tenements and housing stock.

Following the First World War, the number of shipyards was reduced to one, and the stream of pre-war trade dwindled. Through the interwar years, Leith had high levels of unemployment. However, the population of Leith was still around 80,000 at the start of the Second World War.

The rundown condition of much of the housing stock in Leith had been recognised since the 1920s. The depression of the 1930s, followed by the interruption of the war and the austerity of the 1950s, meant that the 'modernisation' of Leith was delayed until the 1960s. When improvement came, the face of Leith was changed forever. The brimming tenements, shops, pubs and small workshops along the old and ancient thoroughfares in the heart of Leith were destined for redevelopment. The Kirkgate, St Andrew Street, Tolbooth Wynd, Bridge Street and many more would disappear during the decade.

After years of industrial decline, slum clearance and depopulation in the post-war era, Leith gradually began to enjoy an upturn in fortunes in the late 1980s. The emphasis moved to urban renewal, community needs and the conservation of Leith's historic buildings.

The town retains a passionate sense of individuality and its people a proud sense of identity. Today, Leith is a thriving port and cruise line destination with many excellent hotels, restaurants and bars. It is also the base of the Royal Yacht *Britannia* and the home of Scotland's Civil Service at Victoria Quay.

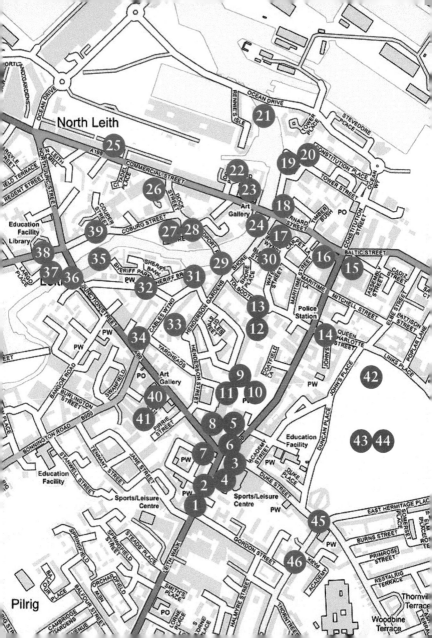

KEY

1. LEITH WALK I

Leith Walk originated from the earthwork constructed in the mid-seventeenth century to defend the northern approach to Edinburgh against Oliver Cromwell's forces. It developed into a broad footpath for pedestrians – hence the name Leith Walk. It was established as the main route between Edinburgh and Leith on completion of the North Bridge, and in 1799 had forty oil lamps installed, making it one of the first streets in Scotland to have public street lighting.

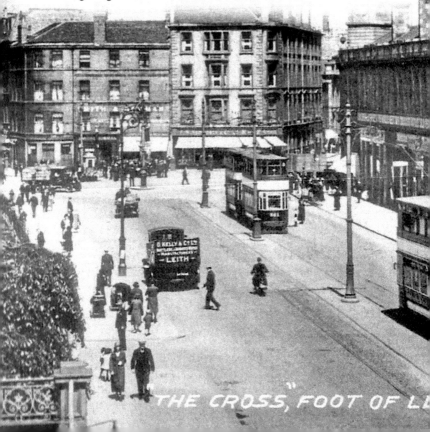

"THE CROSS," FOOT OF L

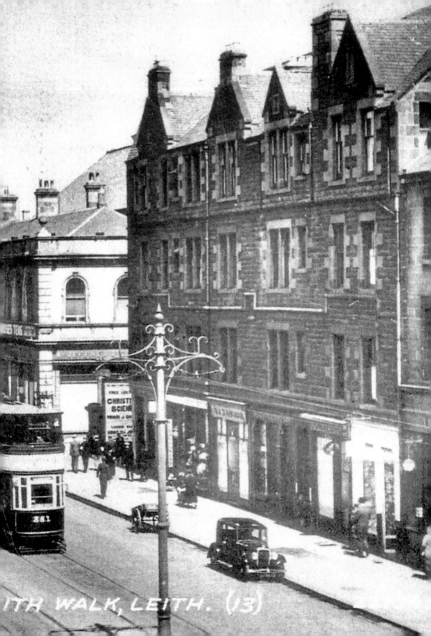

ITH WALK, LEITH. (13)

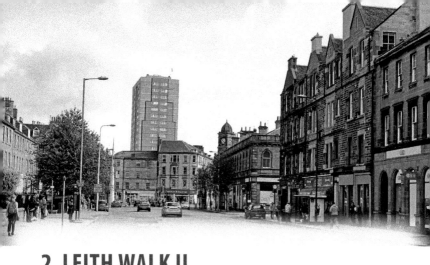

2. LEITH WALK II

Leith Corporation Tramways ran on electric traction and Edinburgh's system was predominantly cable run. Passengers travelling either way along Leith Walk had to change trams at Pilrig, Leith's former boundary with Edinburgh. The merger of the two burghs in 1920 formed the catalyst for the upgrade of the Edinburgh network to an electric system. Electric trams finally crossed the frontier on 20 June 1922 and the chaotic interchange known as 'the Pilrig Muddle' was eradicated.

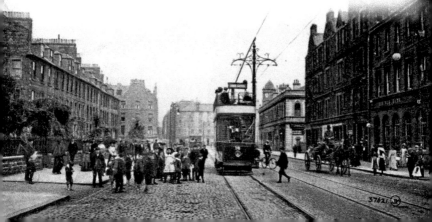

3. LEITH CENTRAL STATION

Leith Central Station was opened on 1 July 1903 by the North British Railway. The seven-minute journey between Leith Central and Waverley, which cost one penny, was known as 'the Penny Jump'. Leith Central Station closed to passenger traffic on 7 April 1952, but continued to be used as a diesel maintenance depot until 1972, when it finally closed. The derelict station was used by drug addicts and was the inspiration for the ironic title of Irvine Welsh's book *Trainspotting*.

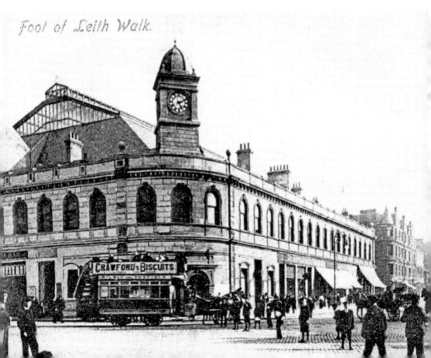

Foot of Leith Walk.

4. THE CENTRAL BAR, LEITH WALK

The Central Bar was completed in 1899, a few years ahead of the station opening. The Central was the station bar and a stair at the rear of the pub provided direct access to the station. This guaranteed a large number of patrons and no expense was spared in the fitting out of the interior. This included decorative tiling with four panels showing sporting activities (yacht racing at the Cowes Regatta; golf, represented by a picture of the Prince of Wales; hare coursing and hunting with pointers).

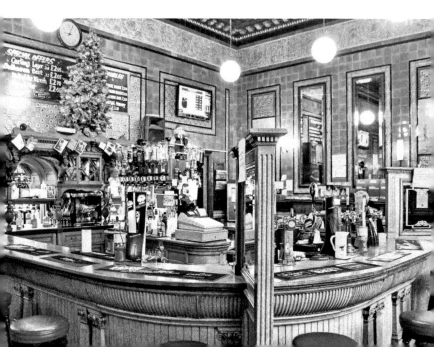

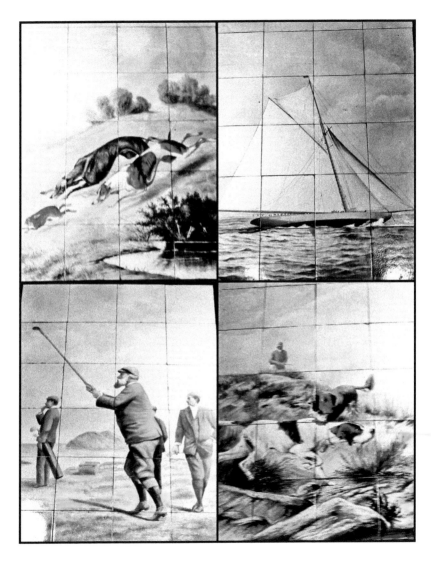

5. FOOT OF LEITH WALK

A view of the Foot of Leith Walk in the 1960s. The buildings fronting the Foot of the Walk are relatively unchanged, although the statue of Queen Victoria has been moved. Smith and Bowman occupied this building at the foot of Leith Walk for decades. The image also provides a glimpse along the Kirkgate, just prior to its redevelopment.

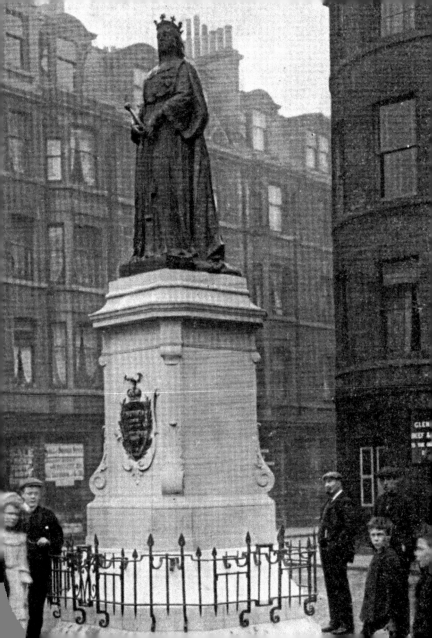

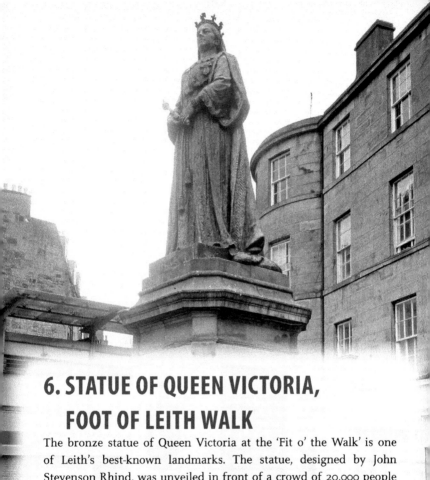

6. STATUE OF QUEEN VICTORIA, FOOT OF LEITH WALK

The bronze statue of Queen Victoria at the 'Fit o' the Walk' is one of Leith's best-known landmarks. The statue, designed by John Stevenson Rhind, was unveiled in front of a crowd of 20,000 people on 12 October 1907 by Lord Roseberry. It is a memorial to the many Leithers of the Royal Scots who fought in the Boer War. In 1913, plaques were added to the plinth to commemorate Queen Victoria's visit to Leith in September 1842. The statue has been moved twice: in 1968 and 2002.

7. GREAT JUNCTION STREET

Great Junction Street was developed from around 1800 as a link between the Foot of Leith Walk and new docks at North Leith. The idea was to bypass the congested streets of historic old Leith. It followed the line of the fortifications of 1548, which had left a strip of open ground.

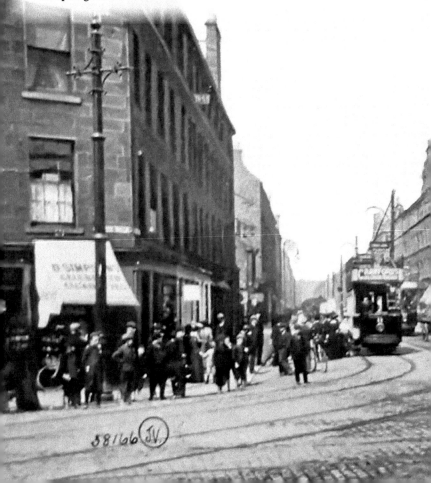

58/66 JV.

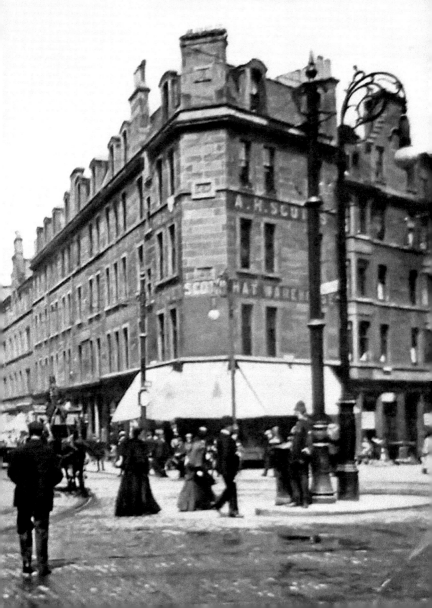

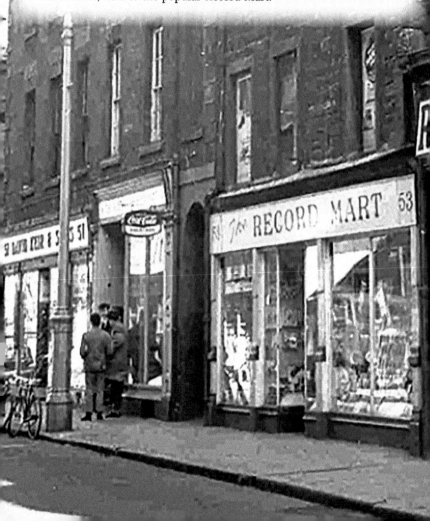

8. THE KIRGATE I

Some of the familiar shops at the top of the Kirkgate from the 1950s and '60s. A group of Teddy Boys congregate outside of the Albert Fish Restaurant, next to the popular Record Mart.

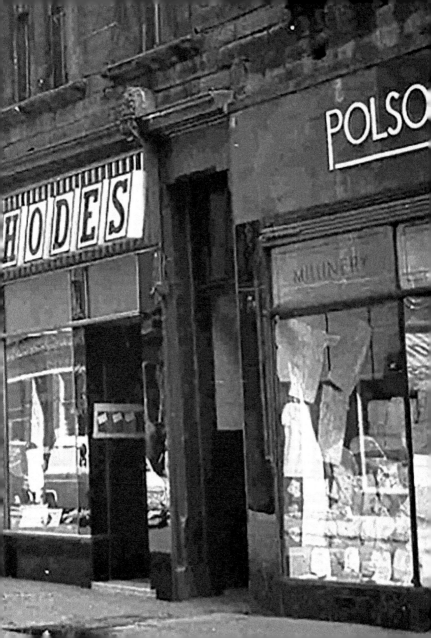

9. THE KIRKGATE II

The Kirkgate was the pulsating heart of Leith. Major slum clearance projects of the 1960s targeted the crammed tenements, shops and small workshops along the old and historic streets in the heart of Leith. The Kirkgate, St Andrew Street, Tolbooth Wynd, Bridge Street and many more were replaced by large public housing schemes and the new Kirkgate shopping centre. The ornamental street lamps are at the entrance to the new Gaiety Theatre, which was opened in 1889 as the Princess Theatre but changed name ten years later to the New Gaiety Theatre and finally closed in 1956.

Kirkgate, Leith

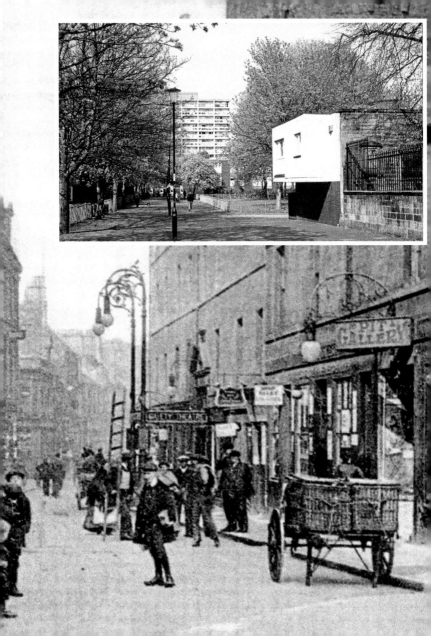

10. SOUTH LEITH PARISH CHURCH

The present South Leith parish church on the Kirkgate dates from 1848 and was built on the site of the sixteenth-century Kirk of Our Lady. In 1645, the church provided relief to the sufferers of the plague in Leith when over 2,700 people fell victim to the disease. The colours of the 7th Company of the Scots Guards are kept at the church in memory of the Gretna Rail Disaster. The graveyard is the burial place of John Pew, the inspiration for Blind Pew in the novel *Treasure Island*; Adam Whyte, Leith's first provost; and Hugo Arnot, the Leith historian.

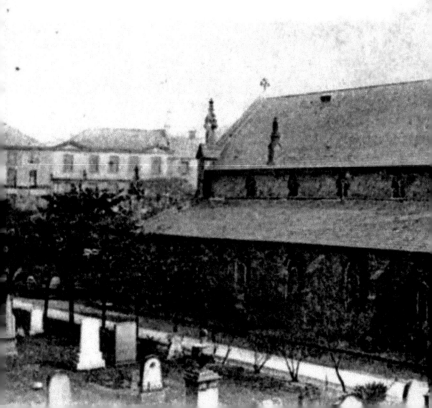

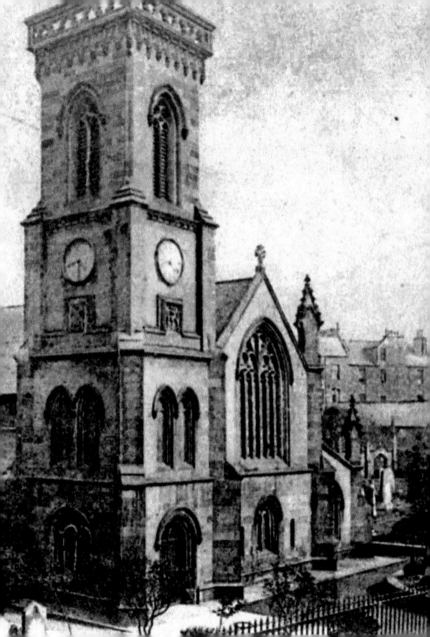

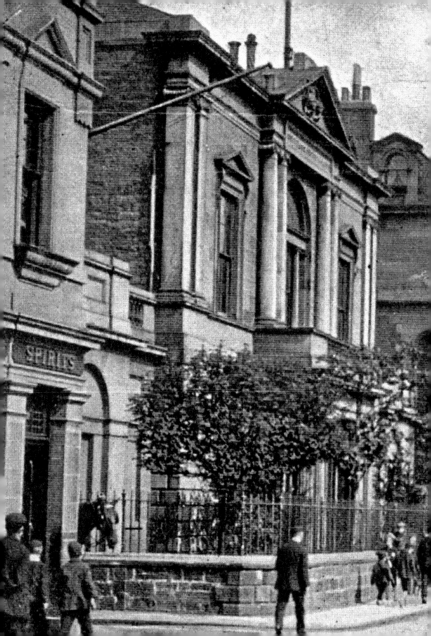

11. TRINITY HOUSE

Trinity House was built on the Kirkgate between 1816–18 as the headquarters of the Fraternity of Masters and Mariners, a charitable foundation for seamen. The current building incorporated the basement and vaults of the former Trinity House and Mariners' Hospital of 1555. The fraternity's original purpose was benevolent, but later it provided pilots for the navigation of the Forth, and was responsible for installing the first oil lamp guide light on May Island.

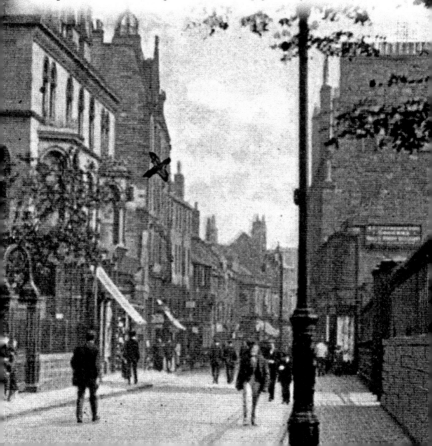

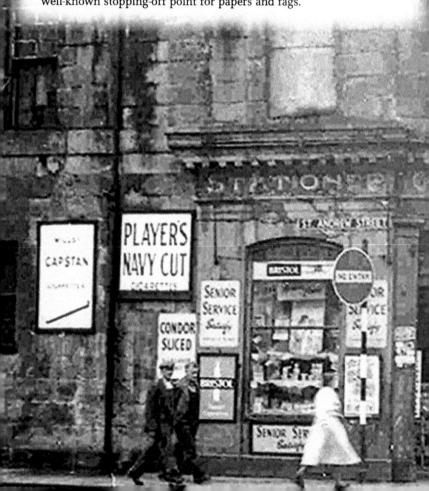

12. MCLAGGAN'S NEWSAGENT, THE KIRGATE

An array of cigarette adverts on McLaggan's Newsagent at the corner of St Andrew Street and the Kirkgate. This newsagent was a well-known stopping-off point for papers and fags.

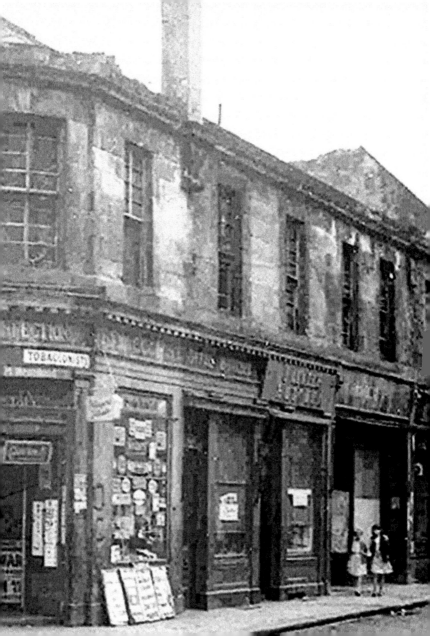

13. TOLBOOTH WYND

Tolbooth Wynd was one of the oldest streets in Leith and it takes its name from the original Leith Tolbooth, which dated from 1565. Its construction was supported by Queen Mary, who wrote to the Edinburgh Town Council requesting that Leith should be allowed to build a 'house of justice'. A stone panel inscribed with the coat of arms of Queen Mary was displayed on the the building, which included a guardhouse and courtroom. It was demolished in 1819, despite the protests of Sir Walter Scott and other antiquarians. Tolbooth Wynd, like the Kirkgate, was noted for its bustling character and wide range of shops. Tolbooth Wynd disappeared with the Kirkgate in the comprehensive redevelopment of the sixties.

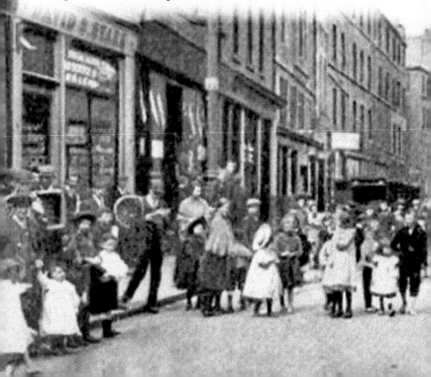

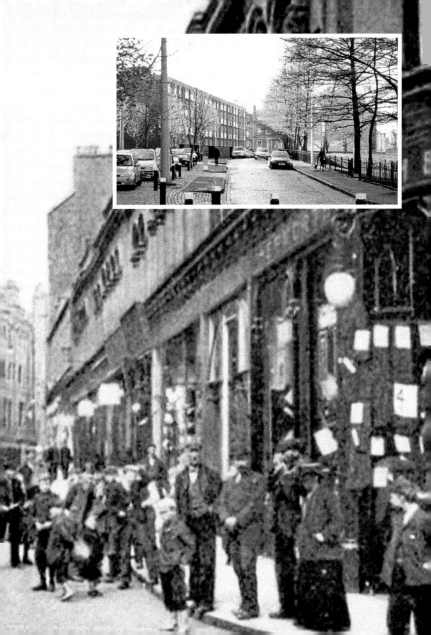

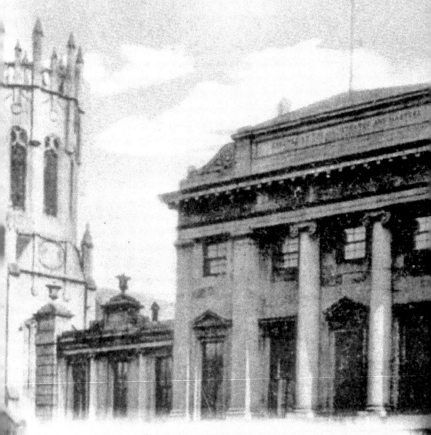

14. LEITH POLICE STATION, CONSTITUTION STREET/QUEEN CHARLOTTE STREET

In 1833, when Leith won its independence from Edinburgh's control and became a separate burgh, the new council took over the existing court building, which had been built five years before. The building

was an important symbol of Leith's independence. Leith's architecture of the time reflected the port's heightened aspirations, and a number of substantial buildings appropriate to its new status were built throughout the nineteenth century. The Leith Police office has been based in the building throughout its history. This is the place where, in the words of the famous tongue twister, the Leith police would have dismisseth us.

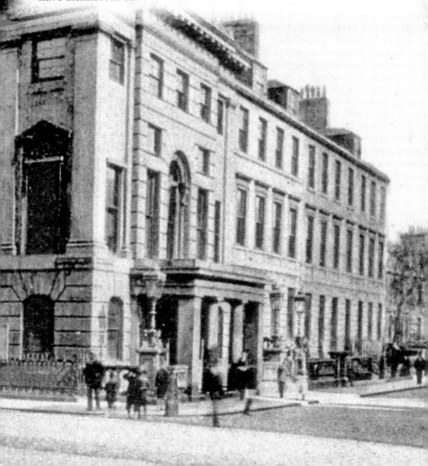

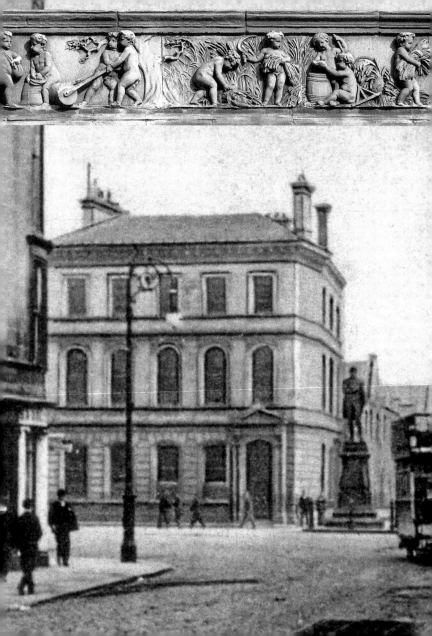

15. ASSEMBLY ROOMS, CONSTITUTION STREET

The Assembly Rooms opened in 1783 as a centre for social events. The adjoining Exchange Buildings were added in 1809 at a cost of £16,000 and were the commercial base of the port of Leith. The domed Corn Exchange was at one time the hub of the trading of grain in Scotland. The building dates to 1862 and includes a distinctive frieze that shows cherubs involved in a range of activities associated with the production and marketing of grain. The Corn Exchange was so spacious that it was often used as a drill hall by the entire battallion of Leith Rifle Volunteers in the nineteenth century.

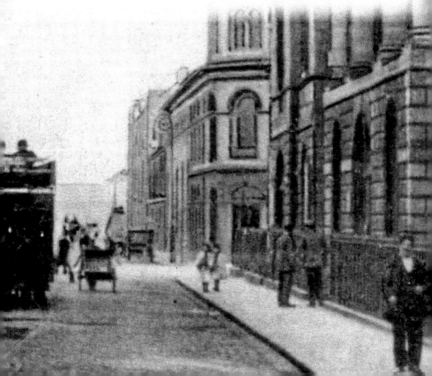

16. BERNARD STREET

Bernard Street is the civic heart of Leith and an outstanding urban space. The street takes its name from Bernard Lindsay, who in 1604 held the title 'Groom of the Bedchamber' to James VI. The centrepiece of Bernard Street is the elegant classical building with the domed roof, which was built in 1806 as the main office of the Leith Banking Co. It was reported that a 'holiday mood' prevailed as thousands gathered on 15 October 1898 for the unveiling of the statue of Robert Burns.

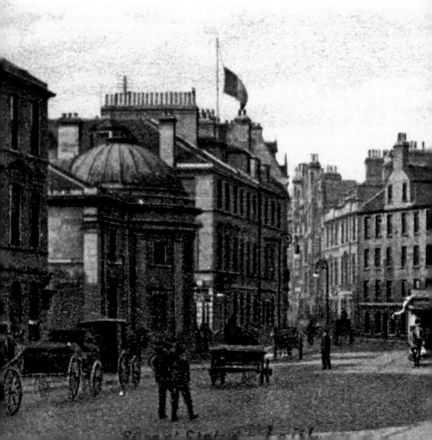

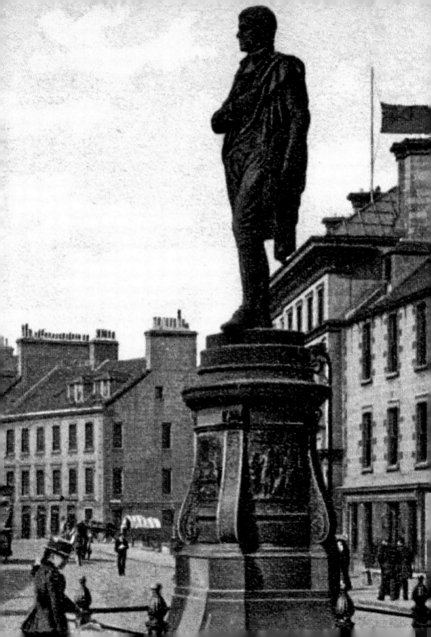

17. THE KING'S WARK

The King's Wark has characteristic Dutch gables and scrolled skewputts in typical early eighteenth-century fashion. It stands on older foundations that were part of a much larger complex of buildings begun by James I in 1434 to serve as a royal residence with a storehouse, armoury, chapel and tennis court. The reputation of the pub, which occupies the building, was once notorious, and it was known locally as 'the Jungle'. It is now a much more salubrious establishment.

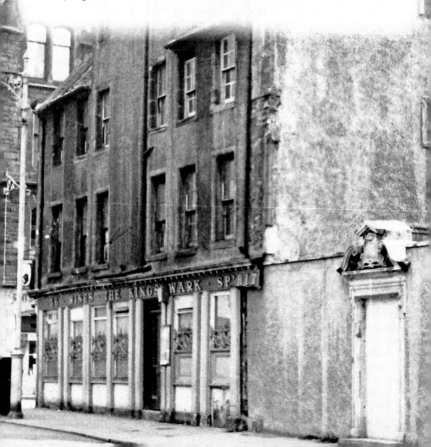

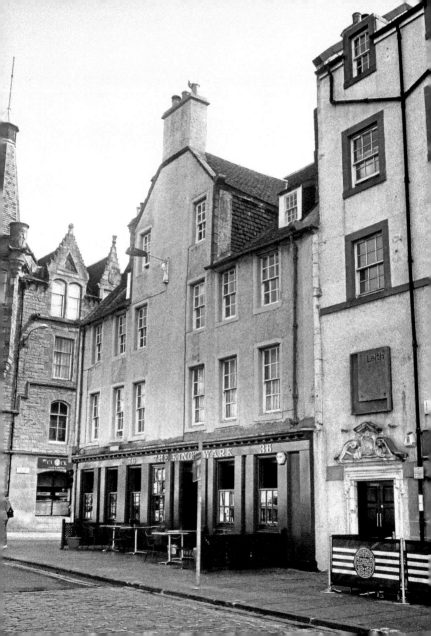

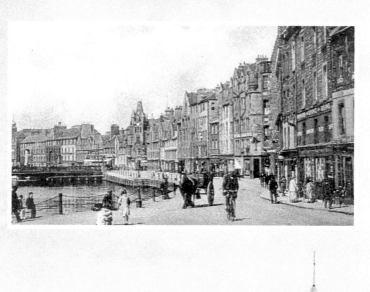

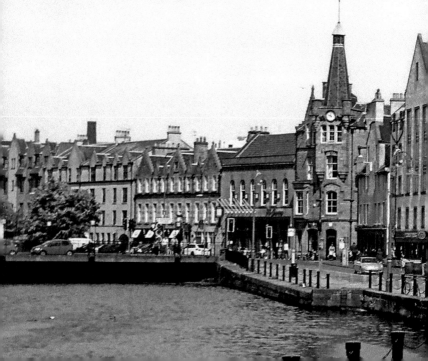

18. THE SHORE I

The Shore is a curving street that leads into the entrance to the docks. Mary, Queen of Scots made landfall from France at The Shore in 1561 and the arrival of George IV on his state visit is marked by a plaque on the quayside.

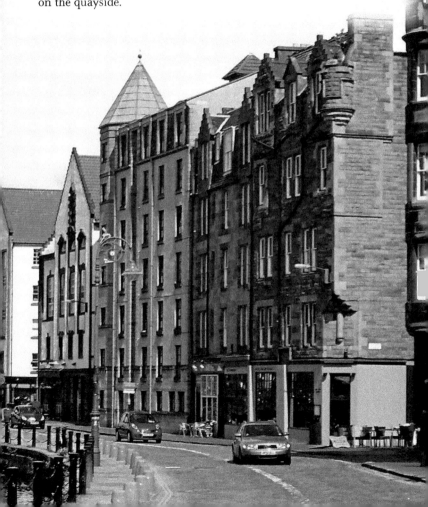

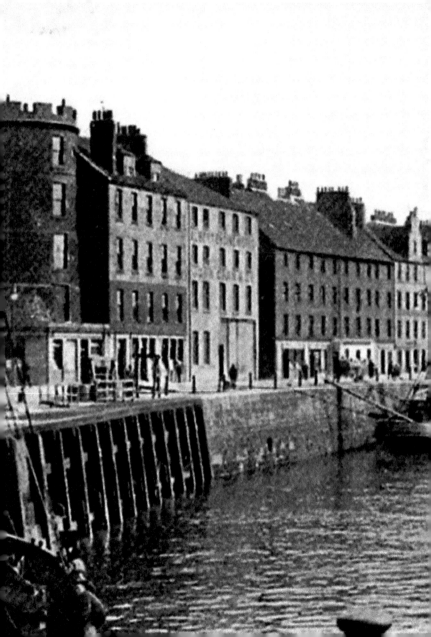

19. THE SHORE II

The Signal Tower, the circular building on the left, is an important Leith landmark at the corner of the Shore and Tower Street. It dates from the seventeenth century and was built originally as a windmill. In 1805, the sails were removed and battlements added. It was used as a signal tower from which flags were displayed to let ships entering the harbour know the depth of water at the harbour bar.

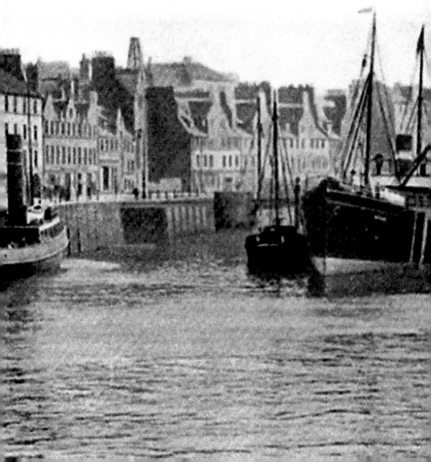

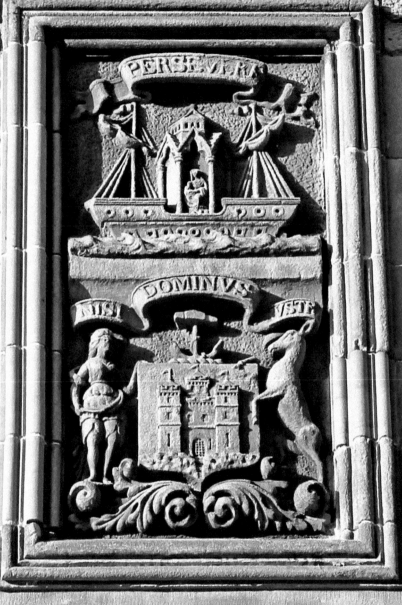

20. THE SHORE, THE SIGNAL TOWER AND SAILORS' HOME

The Sailors' Home was opened on 29 January 1885. It provided a dry warm bed for sailors from around the globe who found themselves in Leith. The building has a number of carvings including Britannia, Nelson and the coats of arms of Leith and Edinburgh. It was converted into the Malmaison Hotel in 1994.

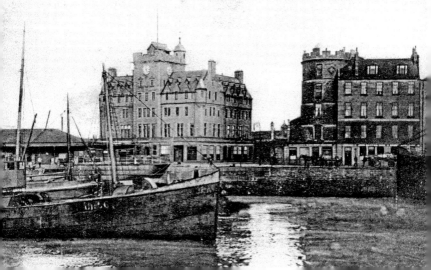

The Sailors' Home and Tower, Leith.

21. THE VICTORIA SWING BRIDGE

The Victoria Swing Bridge was opened in 1874 to link the Victoria Dock with the Albert and Edinburgh Docks. It was the largest swing bridge in the United Kingdom until the opening of Kincardine Bridge in 1937. The bridge was hydraulically operated to allow ships to pass up the Water of Leith. The bridge no longer swings and the road and the rail tracks have been removed. A new fixed road bridge has been built immediately downstream of the old bridge to link motor traffic through to the Ocean Terminal shopping centre.

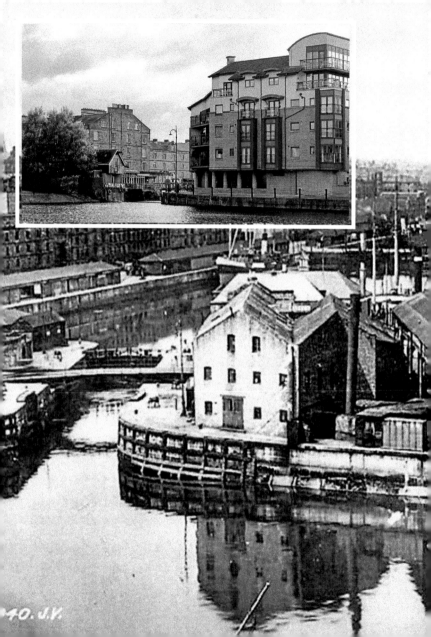

40. J.V.

22. LEITH DOCKS

The original harbour at Leith was a quay at the mouth of the Water of Leith. This was upgraded by the East and West Old Docks in the early nineteenth century. The work was so expensive that Edinburgh agreed to the town's independence in 1833 to avoid paying for them. The Victoria Dock followed in 1851, the Prince of Wales Graving Dock was added in 1858 and the Albert Dock, which was the first in Scotland with hydraulic cranes, was completed in 1869. The Edinburgh Dock was built for coal delivery in 1881, and the final wet dock, the Imperial Dock, was completed in 1898. A second large graving dock, the Alexandra, was added beside the Prince of Wales Dock in 1896. The Forth Ports Authority was established in 1968 to control the ports on the Forth with its headquarters at Leith.

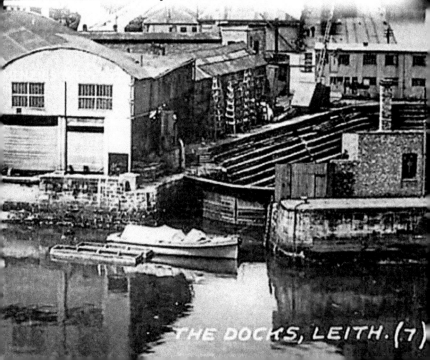

THE DOCKS, LEITH. (7)

23. CUSTOM HOUSE, COMMERCIAL STREET

The Custom House in Commercial Street was designed by Robert Reid and opened for the business of collecting duty on goods imported through Leith in 1812. Its Greek Doric Revival style is typical of the way Leith buildings of the period tended to reflect on a smaller scale those of the neoclassical New Town of Edinburgh. It is located on the site of the old ballast quay and was a replacement for the Custom House in Tolbooth Wynd.

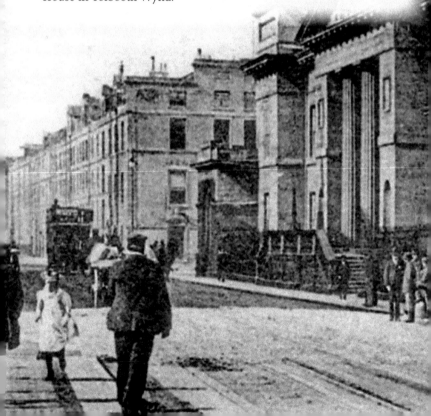

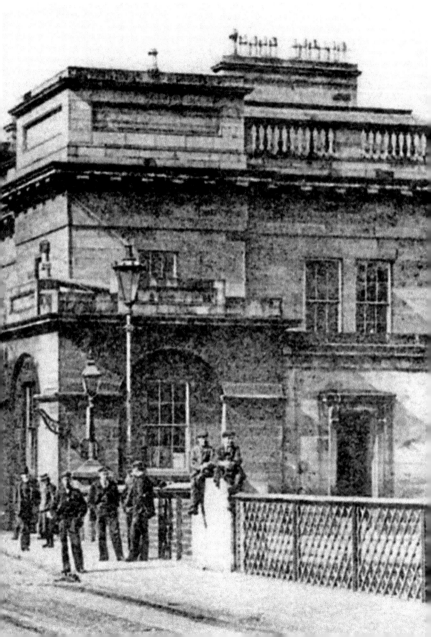

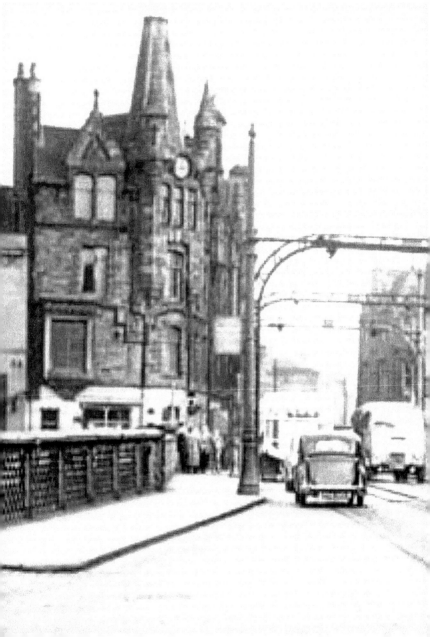

24. BERNARD STREET BRIDGE

The large hoop-like structures carried the electric tram cables so that the bridge could still open for ships. The swing bridge was replaced by a fixed structure in the 1960s.

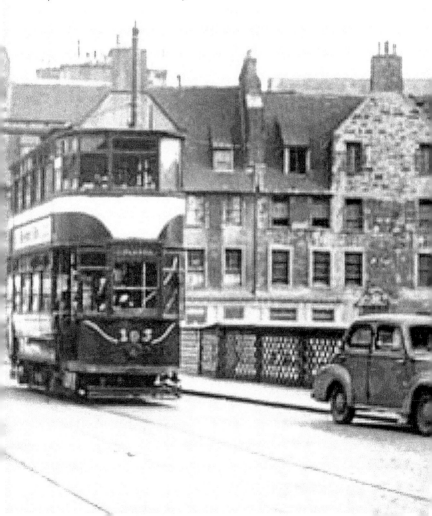

25. LEITH NAUTICAL COLLEGE, COMMERCIAL STREET

Leith Nautical College was originally founded as Leith Navigation School in 1855 at the Mariner's Church in Commercial Street. In 1903, the school moved to purpose-built premises in Commercial Street and changed its name to Leith Nautical College. The Commercial Street college closed in 1977 and moved to new premises in Milton Road. Many Leith seamen will have fond memories of their training days at the college.

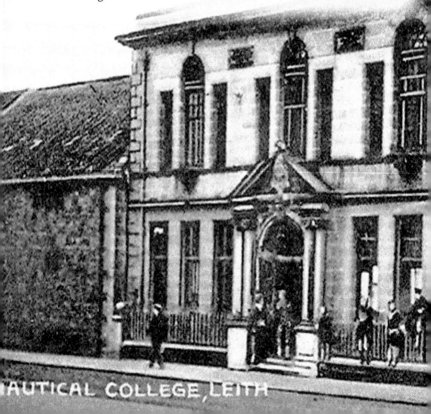

AUTICAL COLLEGE, LEITH

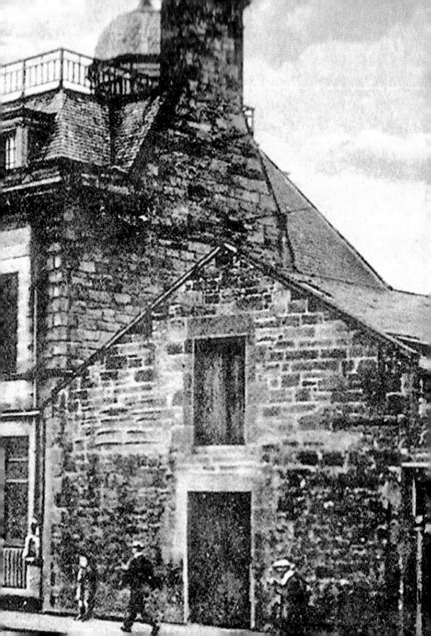

26. LEITH CITADEL, DOCK STREET

This arch in Dock Street was the main entrance to the seventeenth-century Leith Citadel. In 1650, Cromwell's army occupied Leith after their victory at the Battle of Dunbar. In 1656, a large fort, Leith Citadel, and barracks were built. The Citadel, 'passing fair and sumptuous', was erected on the site of the Chapel of St Nicholas at the foot of Dock Street. The house over the archway, according to tradition, was the meeting place of the officers and men of Cromwell's Ironsides in Leith.

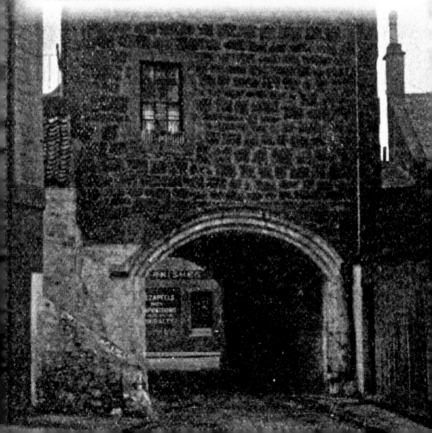

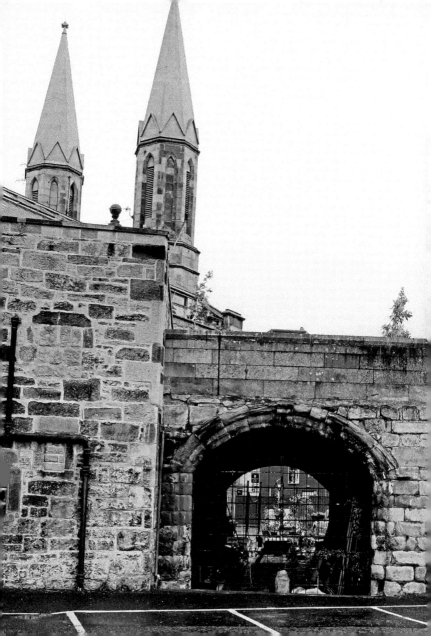

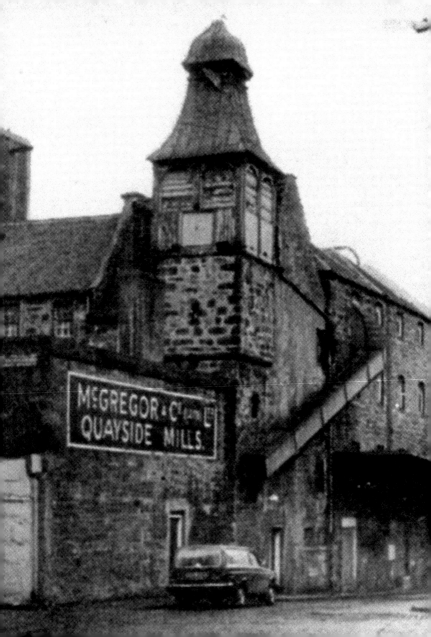

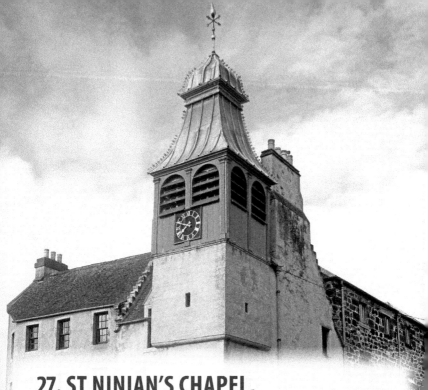

27. ST NINIAN'S CHAPEL, QUAYSIDE STREET

In 1493, Robert Bellenden, the Abbot of Holyrood, founded the chapel dedicated to St Ninian on the bank of the Water of Leith. It is the oldest building in Leith. It fell into ruin after the Reformation, was restored in 1595 and became the church of a new parish of North Leith in 1606. It was rebuilt and extended in the late seventeenth century, when the distinctive steeple was added. In 1816, the congregation moved to a new church in Madeira Street. In 1825, St Ninian's was converted for commercial purposes as a granary and a mill. It was restored as offices in 1997.

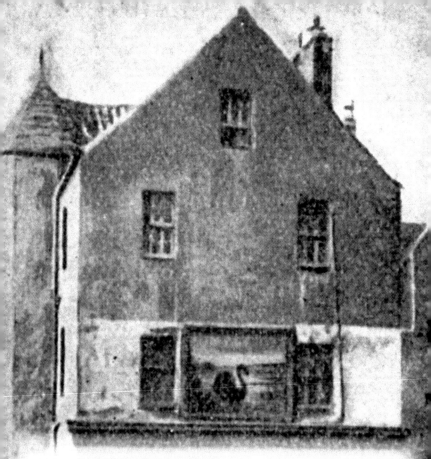

28. THE BLACK SWAN

The original Black Swan was the village inn of North Leith, allegedly frequented by old salts and pirates spinning tales of the high seas. It was rebuilt in 1892 and continued trading as The Black Swan. Over time the tales changed to those of the perils of whale hunting in the icy seas of South Georgia. The Black Swan forfeited its name – which it held for generations – in recent years and is now the popular Roseleaf Café.

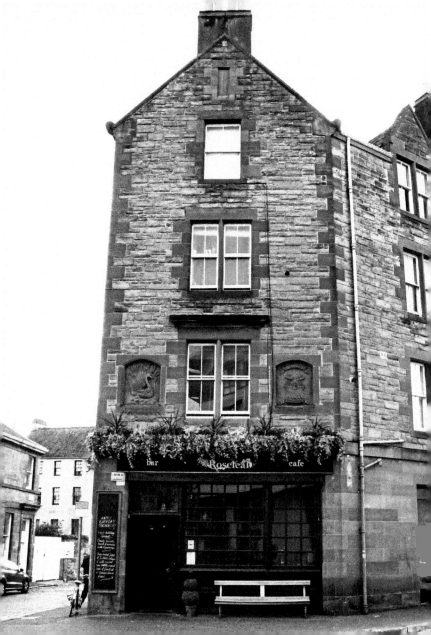

29. THE SHORE, THE UPPER DRAWBRIDGE

A group of Leithers on the Upper Drawbridge in 1909. This bridge replaced the nearby fifteenth-century Brig o' Leith crossing in 1787. It allowed ships to berth further upstream. The Lower Drawbridge was a crossing from the rear of the Custom House to The Shore and was removed in March 1910. (Photograph courtesy of Archie Foley)

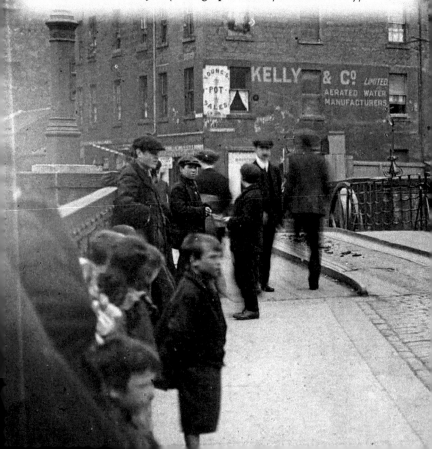

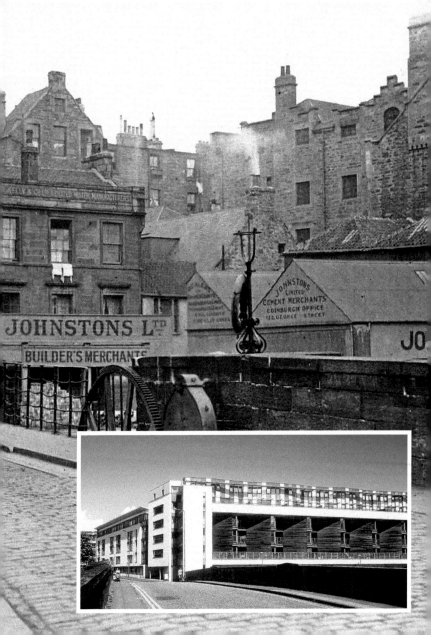

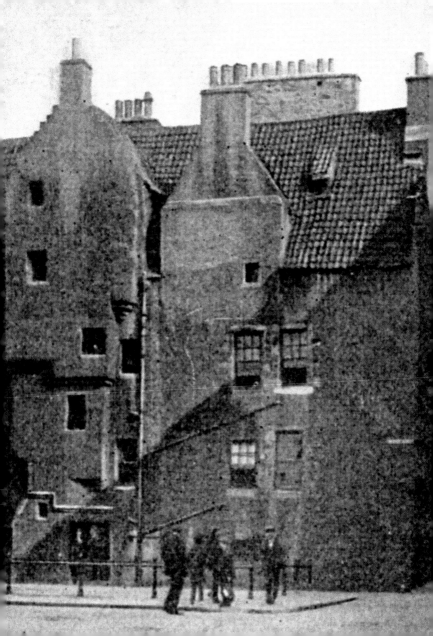

30. ANDRO LAMB'S HOUSE, WATERS' CLOSE

Lamb's House in Waters' Close, off Burgess Street, is one of the largest and most architecturally impressive seventeenth-century merchant's houses in Scotland. The house takes its name from Andro Lamb, the first recorded owner. Legend has it that Mary Queen of Scots rested for an hour in the house when she arrived in Leith on 19 August 1561; but the house was not standing at the time. In the early twentieth century, the building was subdivided into a number of flats and by the 1930s was in a derelict condition. The Marquess of Bute stepped in to buy the building for £200 in 1938. It was restored by the architect Robert Hurd and in 1958 the building was gifted to the National Trust for Scotland. It was then leased to the Edinburgh and Leith Old People's Welfare Council and used as a day centre for the elderly. It has now been expertly restored as a family home.

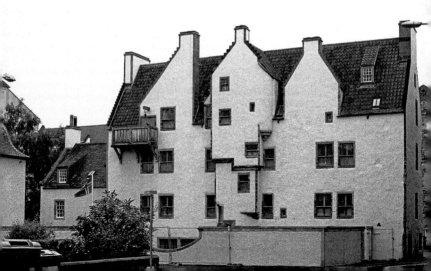

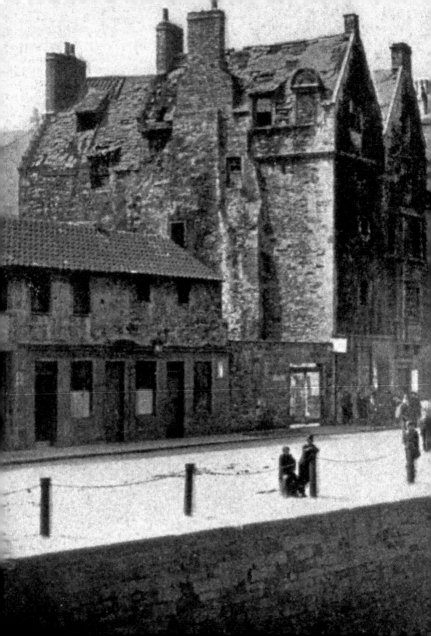

31. COALHILL

This old postcard view is titled Mary of Guise's House, Coalhill. In 1548, during the civil war between Mary of Guise and the Scottish Protestant Lords, the Queen Regent moved the seat of government to Leith, built fortifications, and held the town for twelve years with support from France. Mary of Guise died in June 1560, and the Siege of Leith ended with the departure of the French troops.

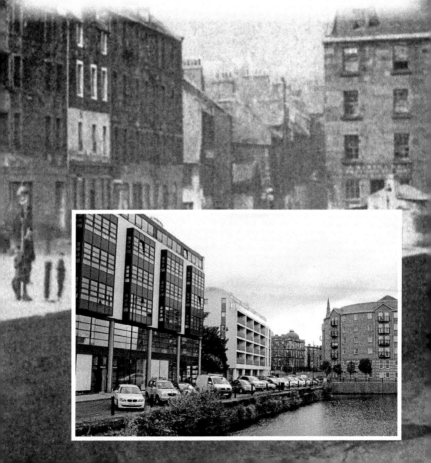

32. FORMER ST THOMAS' CHURCH, SHERIFF BRAE

St Thomas' Church dates from 1840–43 and was founded by Sir John Gladstone, the son of Thomas Gladstone, a Leith-born flour merchant and father of British Prime Minister William Ewart Gladstone. Sir John made a fortune in the corn trade and was inspired to build the church in memory of his wife, who passed away in 1835. The development originally included a manse, school and hospital. In April 1916, the manse was destroyed during a Zeppelin raid. The church survived the raid intact and continued in use until May 1975. In 1976, the building found new life as the Guru Nanak Gurdwara Sikh temple.

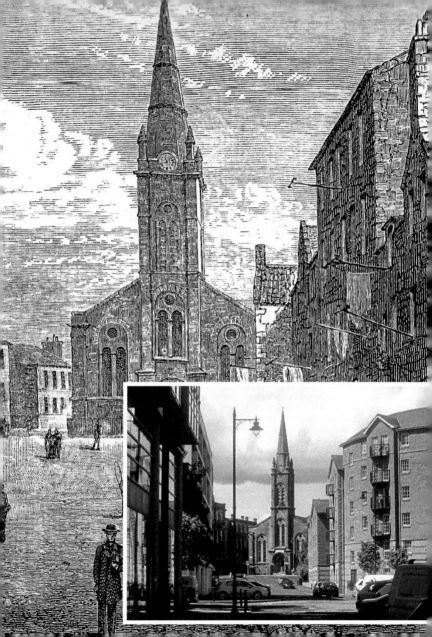

33. CABLES WYND HOUSE

Cables Wynd House, or, as it is better known, 'the Banana Flats', was built between 1963 and 1965. It is a long ten-storey slab block and takes its soubriquet from the bend in the middle that gives it the appearance of something that resembles a banana. It famously makes an appearance in Irvine Welsh's *Trainspotting* as the childhood home of Simon 'Sick Boy' Williamson. Cables Wynd House is considered an important surviving example of post-war multistorey blocks, representing a time of major social change. At the time of writing, Cables Wynd House was rather controversially designated, along with the slightly later multistorey Linksview House, as a Category 'A'-listed building.

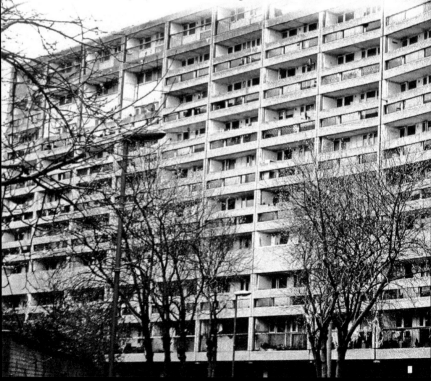

34. LEITH PROVIDENT CO-OPERATIVE SOCIETY, GREAT JUNCTION STREET

The turreted building was built in 1911 as a department store for the Leith Provident Co-operative Society. Co-operative societies allowed customers to obtain membership, effectively becoming stakeholders in the company. Each customer was assigned their own specific dividend number, or 'divi', which would see them receive a payment at the end of the financial year based on how much they had spent. The Leith Provident was taken over by the Edinburgh-based St Cuthbert's Co-operative Society in 1966.

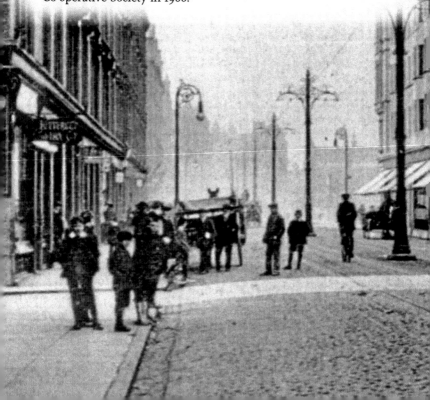

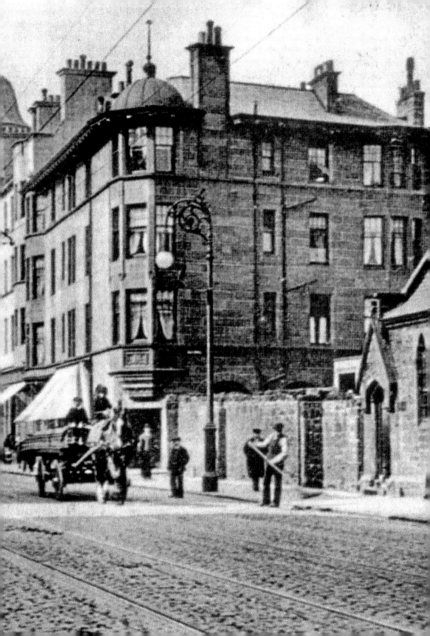

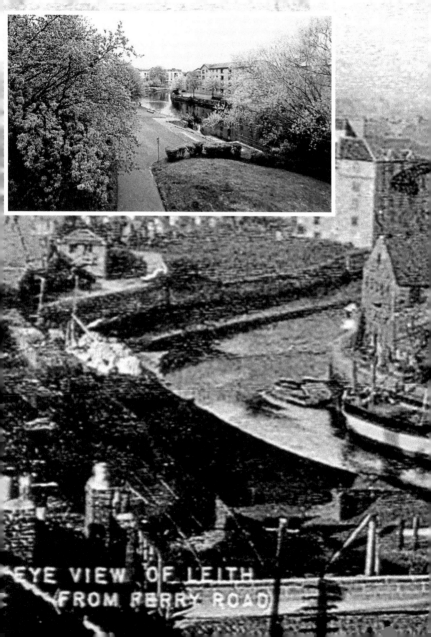

EYE VIEW OF LEITH
FROM FERRY ROAD

35. BIRD'S-EYE VIEW OF LEITH FROM FERRY ROAD

A much-changed view of Leith from Ferry Road. The older image has been taken from the upper floors of a tenement on Ferry Road. There are no tram wires on the bridge, which dates the photo to pre-1905. The photo shows the roof of the entrance to Junction Road Station at the bottom right. The number of factory chimneys reflects the industrial nature of Leith at the time. Hawthorn's shipbuilding and engineering yard, with a moored ship outside, is to the right of the Water of Leith. On the opposite side of the river it is just possible to see the railway.

36. GREAT JUNCTION STREET BRIDGE

A view over the Great Junction Street Bridge in 1904. The Junction Bridge Station building can be seen on the right-hand side (behind the hoardings) where passengers descended to the platforms below.

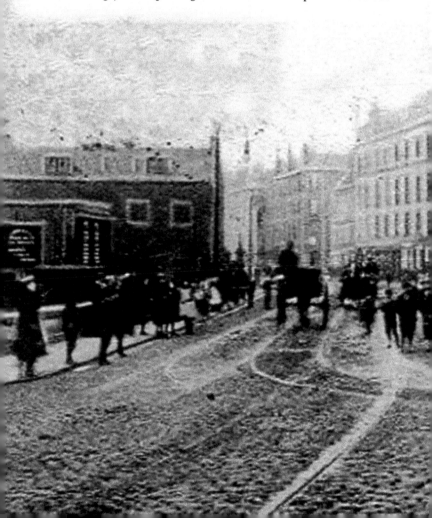

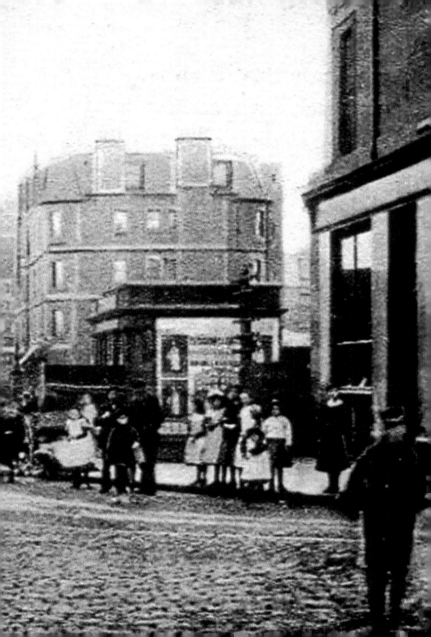

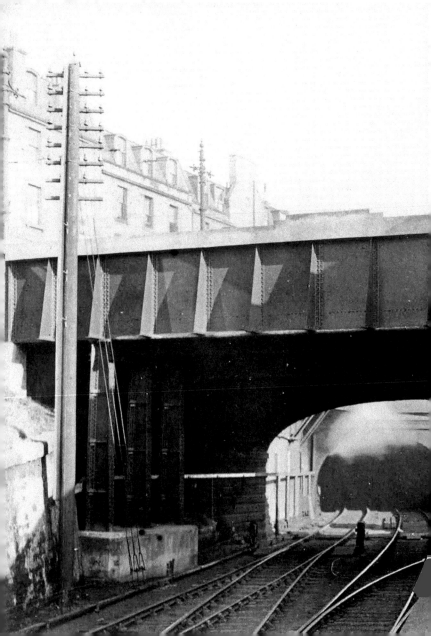

37. JUNCTION BRIDGE STATION

Junction Bridge Station is seen here in 1909 huddled beneath Great Junction Street Bridge. The yawning tunnel ahead eventually led to the Citadel Station on Commercial Street. It was the branch line for the Edinburgh, Leith & Newhaven Railway carrying freight and passengers to the port. The staircase up to Great Junction Street is on the right-hand side of the image. (Photograph courtesy of Archie Foley)

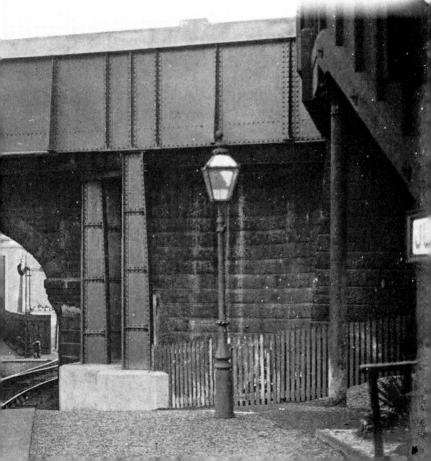

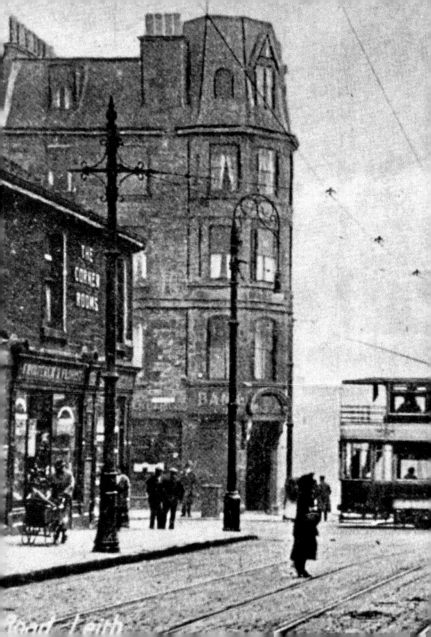

THE CORNER ROOMS

Road Leith

38. FERRY ROAD AT NORTH JUNCTION STREET

An electric tram passing on North Junction Street towards Junction Bridge. The sign for the Corner Rooms is prominent on the left of the image. The Corner Rooms on the junction of North Junction Street and Ferry Road hosted all sorts of activities, from dance classes to weddings. Today, this is an open-air seating area with the Leith Mural on the gable wall.

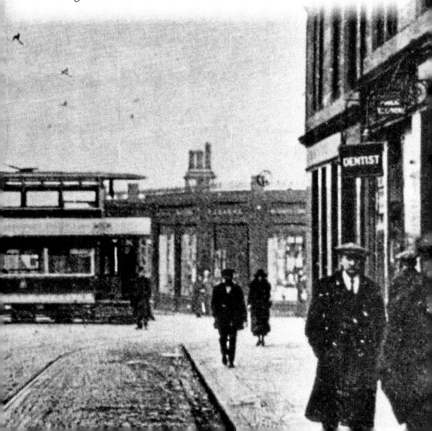

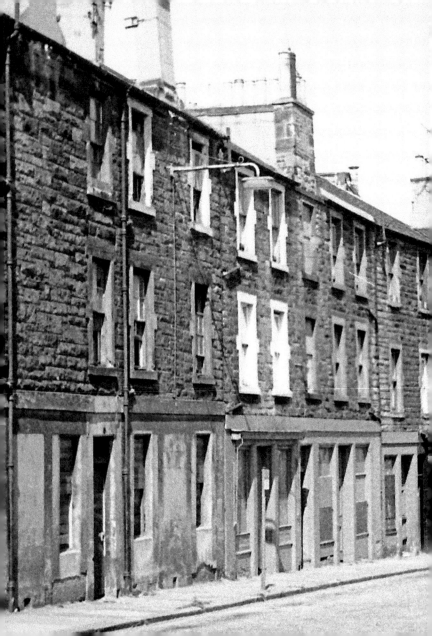

39. COBURG/COUPER STREET

The headquarters and warehouse of Melrose's Ltd tea and coffee merchants at Nos 55–57 Couper Street. Melrose's was a popular brand and they had a number of shops in the Edinburgh area. Andrew Melrose established the company in 1812 and when the tea clipper *Isabella* landed a consignment of tea at Leith in 1835, Melrose became the first tea merchant to import tea into Britain outside of London. The warehouse, which dates from around 1900, has been converted into flats.

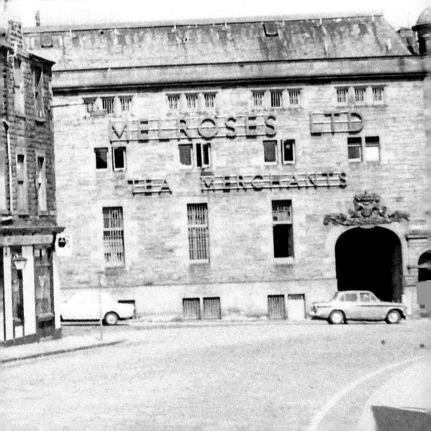

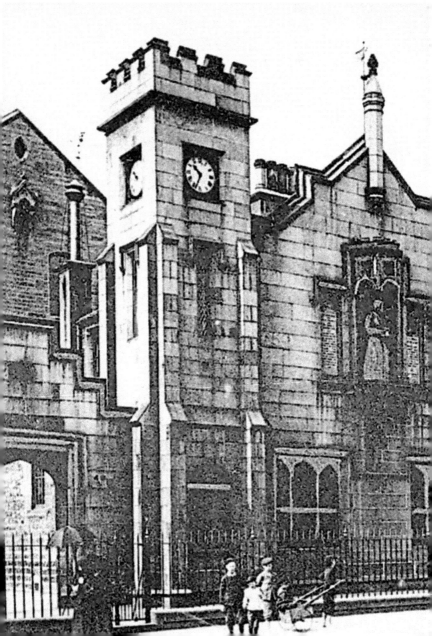

40. DR BELL'S SCHOOL, GREAT JUNCTION STREET

Dr Bell's School on Great Junction Street was built in 1839. Dr Andrew Bell (1753–1832) was a minister and an important educationalist who was born in St Andrews. He developed an innovative form of education – the Madras System – during his time in India as a school superintendent. It was based on more advanced pupils helping younger pupils in the school.

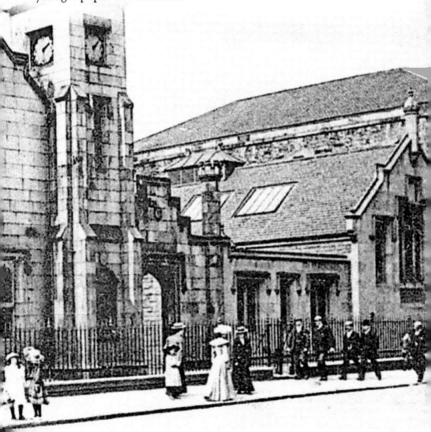

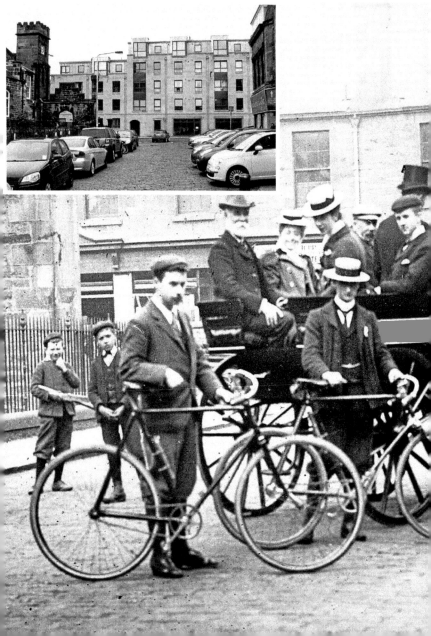

41. JUNCTION PLACE

A gathering of well-dressed Leithers, with bikes and a carriage, prepare to set off for a day trip. Meanwhile, other locals regard the scene with some interest and possibly suspicion on the corner with Great Junction Street.

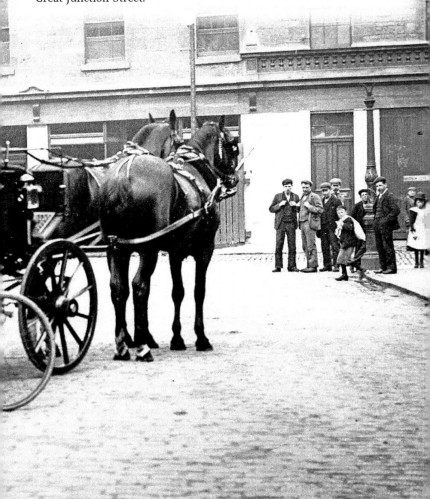

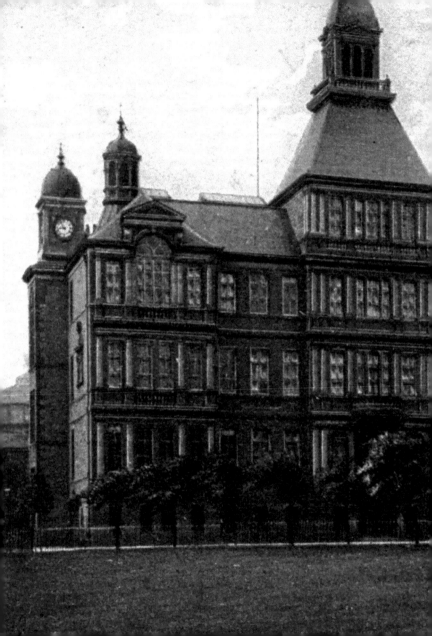

42. LEITH ACADEMY, ST ANDREW PLACE

This imposing red-sandstone building on St Andrew Place overlooking Leith Links was the home of Leith Academy for 125 years. Leith Academy has the longest history of any school in Scotland. It is believed to have been founded in 1560 and associated with South Leith parish church. Its first recorded premises were Trinity House in 1636, where it was based until 1710. After a disagreement about the £3-a-year rent, the school moved to a building on South Leith parish churchyard. The custom-built premises on St Andrew Place were occupied by the school from 1806 until 1931 when increasing numbers resulted in the building of Leith Academy. The latest Leith Academy on Academy Park was opened in May 1991. The St Andrew Place building is now used by Leith Primary School.

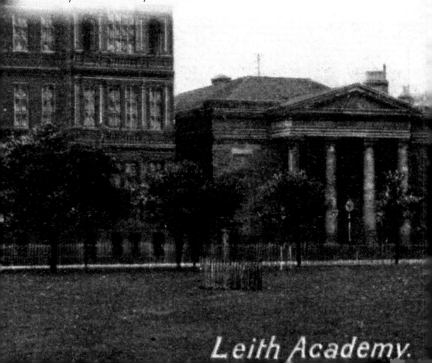

Leith Academy.

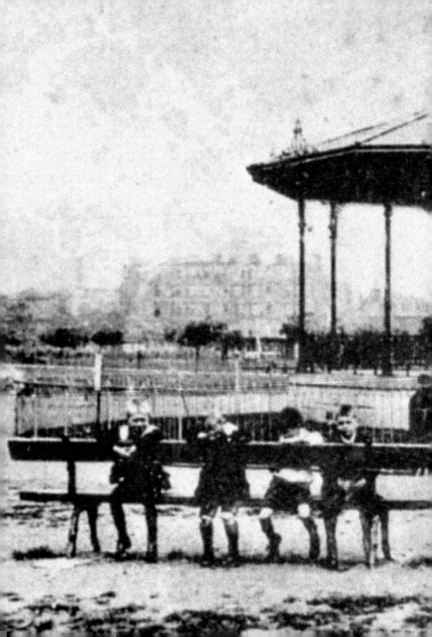

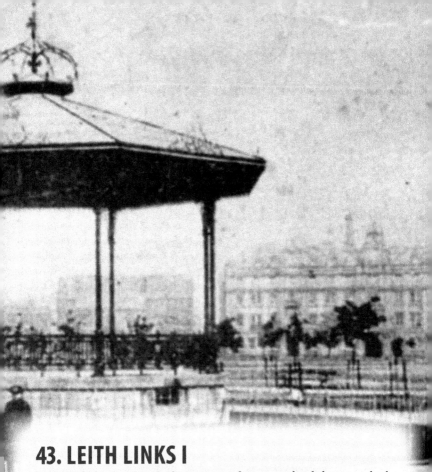

43. LEITH LINKS I

Leith Links were part of a larger area of common land that stretched along the coast including part of Seafield. The two mounds, the Giant's Brae and Lady Fyfe's Brae, at the western end of the Links are believed to be artillery mounds – Somerset's Battery and Pelham's Battery – used during the 1560 Siege of Leith. The Links were also the last resting place of hundreds of casualties of the 1645 plague outbreak that wiped out half of the population of Leith.

44. LEITH LINKS II

Links is from the Scots meaning 'sandy ground with hillocks and dunes'. The present artificial flatness of Leith Links dates from around 1880 when the ground was remodelled into a formal park. These improvements removed most of the world's oldest golf course, which is mentioned as early as 1456 when James II imposed a ban on the game because it disrupted archery practice on the Links. The first rules of golf, which are the basis of the modern game, were drawn up in 1744 for use on the Links by Leith's Honourable Company of Edinburgh Golfers.

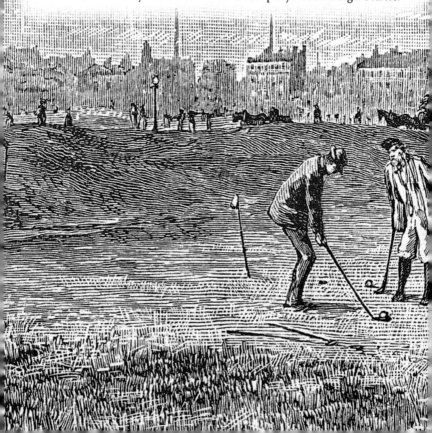

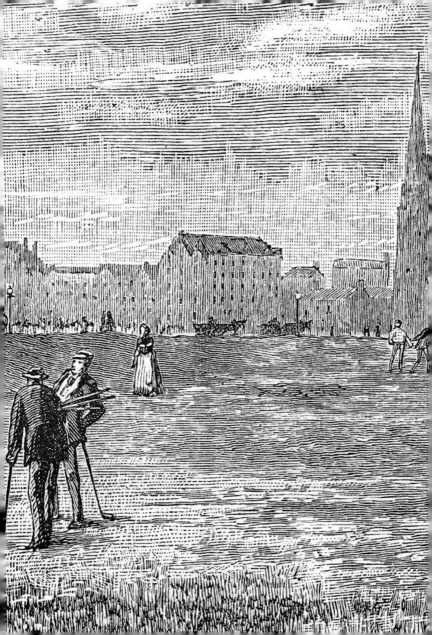

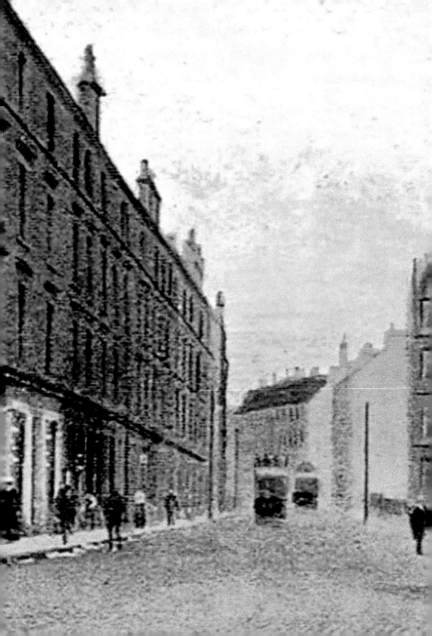

45. DUKE STREET

Duke Street was named after the Duke of Dalkeith in 1812. He was an enthusiastic golfer and rented a house in the area to be close to the course at Leith Links. This view is from the roundabout at the foot of Easter Road. Duncan Place is to the right behind the small brick building, which was a tram/bus turnaround stop for crew to have tea and loo break.

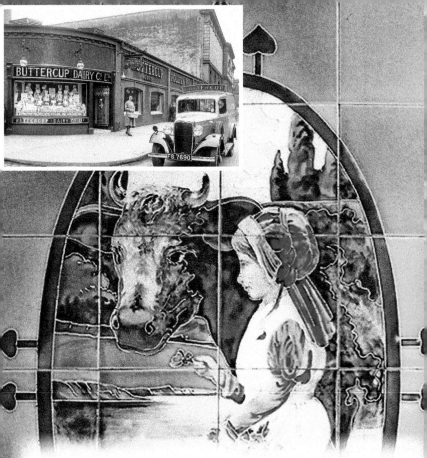

46. BUTTERCUP DAIRY, EASTER ROAD

The Buttercup Dairy Co., founded by Andrew Ewing, established its headquarters in Elbe Street in 1894, and following rapid expansion moved to Easter Road in 1915. It was one of the first chain stores with over 250 shops throughout Scotland. The shops were famous for their beautiful tiled 'girl and cow' murals. (Photograph courtesy of Bill Scott www.buttercupdairycompany.co.uk)